A Basic Guide to

NORTHWEST COAST FORMLINE ART

COMPILED BY

Rico *Lanáat'* Worl

Shaadoo'tlaa

Donald *Héendeí* Gregory

Sealaska Heritage Institute

Juneau

SEALASKA HERITAGE INSTITUTE
One Sealaska Plaza, Suite 301
Juneau, Alaska 99801
907.463.4844 • 907.586.9293 (f)
www.sealaskaheritage.org • www.alaskanativeartists.com
www.jineit.com • sealaskaheritagecenter.com

ISBN 978-0-9853129-7-8

Cover: Formline by Amos Wallace, from the Sealaska Heritage Institute Collection.
Design by Christy *NaMee* Eriksen.

Design and Composition by Christy *NaMee* Eriksen and Kathy *K'éi Joon* Dye.

Illustrations: Cover by Amos Wallace; pages 3–6, shapes by Rico *Lanáat'* Worl; page 7, human figure by Donald *Héendei* Gregory; page 8, Box design by Yukie Adams; pages 10–13, box design graphic based on old box; page 15, human figure by Donald *Héendei* Gregory; page 16, eagle profile by Crystal *Kaakeeyáa* Worl; page 17, eagle front by Donald *Héendei* Gregory; page 18, raven profile by Amos Wallace; page 19, raven front by Donald *Héendei* Gregory; pages 21–22, salmon and killerwhale by Amos Wallace; page 23, beaver by Nathan Jackson; page 24, frog by Amos Wallace; pages 25–26, bear and wolf by Donald *Héendei* Gregory; page 27, shark by Amos Wallace; page 28, *Chilkat Shirt Design* by Ray *Aaan eetí lootl* Peck.

This project was supported in part by a grant from the Alaska Humanities Forum and the National Endowment for the Humanities, a federal agency. Any views, findings, conclusions, or recommendations expressed in this publication do not necessarily represent those of the National Endowment for the Humanities.

 ALASKA HUMANITIES FORUM NATIONAL ENDOWMENT FOR THE Humanities

TABLE OF CONTENTS

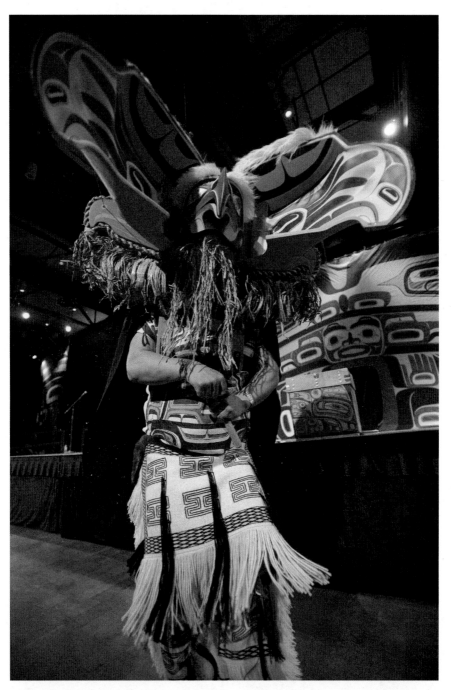

THIS DANCER'S TRANSFORMATION MASK, HIS REGALIA, AND THE BOX AND
SCREEN IN THE BACKGROUND ARE ADORNED WITH FORMLINE. REG DAVIDSON
OF THE "TUULGUNDLAAS XYAAL XAADEE" RAINBOW CREEK DANCERS AT
CELEBRATION 2006. PHOTO BY BILL HESS, SEALASKA HERITAGE INSTITUTE
COLLECTION.

INTRODUCTION

Art is integral to the life ways of the Tlingit, Haida, and Tsimshian. It surrounds us and it holds us up. Our Northwest Coast art is ingrained in the social fabric and oral histories of our clans. It is characterized by formline—a term used to describe the unique artistic style of the indigenous people of the Northwest Coast. Formline is a composition of lines whose widths vary to create form. The overall collection of these compose an image or design.

The formline designs may represent stories of Raven (the Trickster), historic events, clan crests, or other concepts. Formline is an art that dates back more than two thousand years (Brown 1998).

Two-dimensional formline is depicted on objects such as bentwood boxes, clan hats, and house screens. Though formline is drawn in two dimensions, it transforms to be adapted to three-dimensional pieces, such as masks and totem poles.

In this booklet we hope to provide a concise and easy-to-understand guide for interpreting Northwest Coast formline art.

DESIGN ELEMENTS

When broken down, the elements of formline originate from these three shapes:

Ovoid:

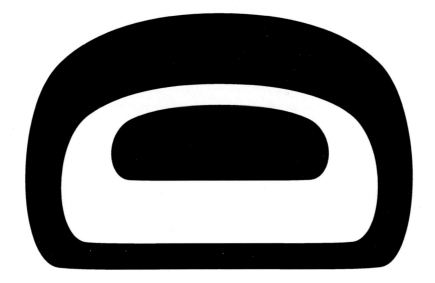

U-Shape: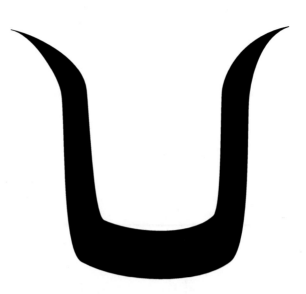

S-Shape: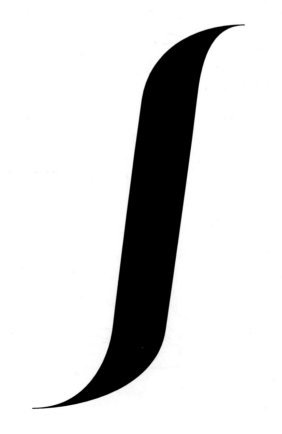

4

Many artists contend the ovoid is the original shape and the basis of all other shapes found in formline. The ovoid's flowing width sets the theme and allows for the forms to merge together when included in a completed composition. Sometimes circles are used instead of ovoids.

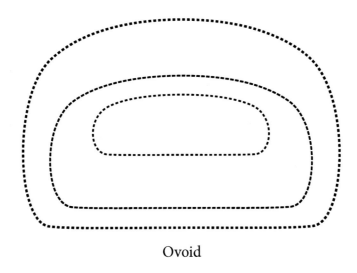

Ovoid

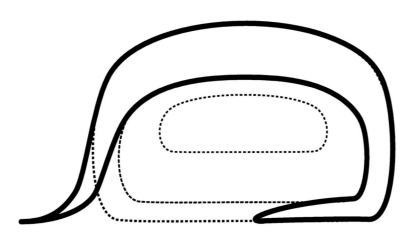

Ovoid transforming to U-shape

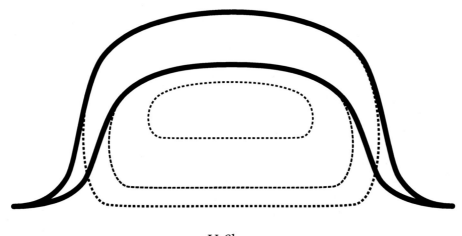

U-Shape

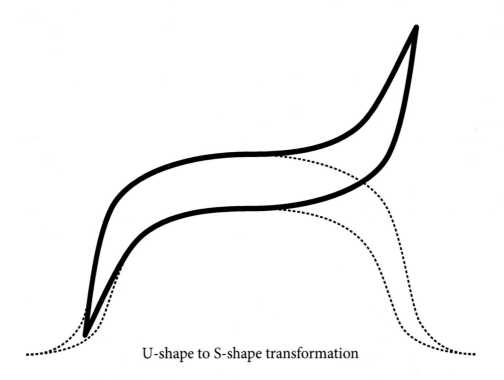

U-shape to S-shape transformation

6

A composition builds from these design elements. This design has
17 ovoids, 8 U-shapes, and 10 S-shapes. Can you find the rest of the
shapes? Keep an eye out for these shapes in the following pages.

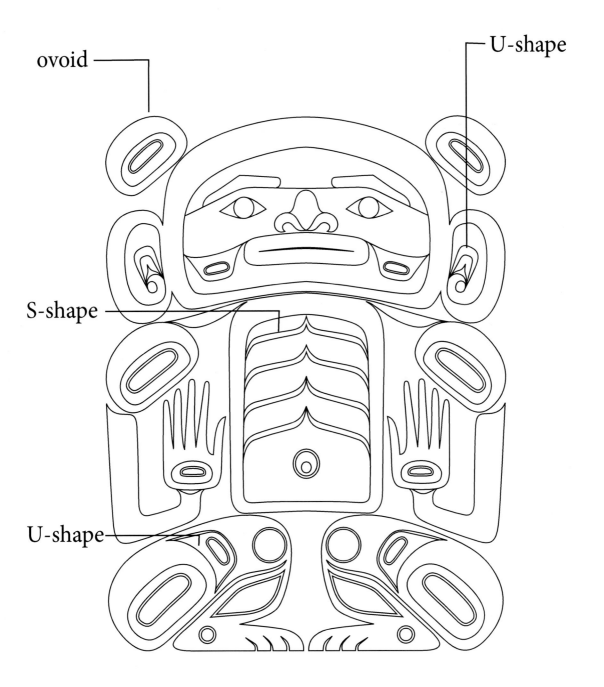

ovoid

U-shape

S-shape

U-shape

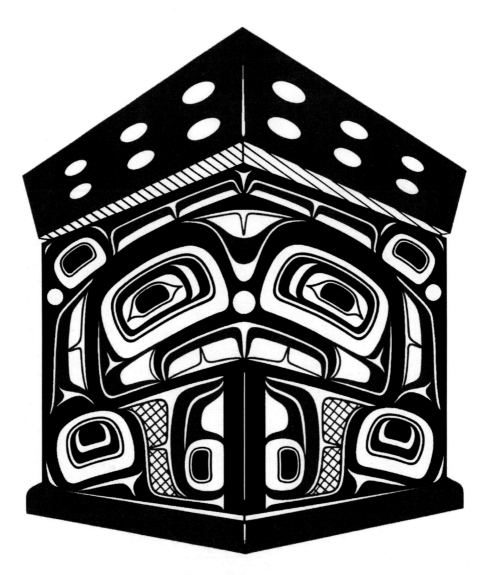

IN THIS BOX DESIGN, THE BLACK REPRESENTS THE PRIMARY SPACE. HOWEVER, THE ARTIST SWITCHED TO RED ON THE CLAWS (BOTTOM, CENTER), WHICH ARE ALSO PART OF THE PRIMARY DESIGN. IT IS NOT UNCOMMON FOR ARTISTS TO CHOOSE TO SWITCH PRIMARY AND SECONDARY COLORS WHEN FILLING THE PRIMARY SPACE.

DESIGN SPACES AND COLORS

Formline has positive and negative spaces. Positive space is filled in or colored while negative space is not. Positive space is broken into three categories: primary, secondary, and tertiary. These are usually most obviously differentiated by color.

The primary space composes the framework of the design. You will see the largest ovoids and U-shapes in the primary design. As Bill Holm notes in *Northwest Coast Indian Art: An Analysis of Form*, "The primary design is typically a continuous design across the entire design. You could place your finger on one part of the primary design and follow that color to any other part of the design." The primary color usually is black.

The secondary space is generally encompassed by primary space and usually is anchored to the primary space in at least one point of contact. The secondary space is used for accent or detail. The secondary color usually is red.

The tertiary space or element is not always present in a design. Tertiary elements will be encompassed by either primary or secondary elements. Tertiary elements are the least-used element in a design and act as accents or details. The tertiary color usually is blue-green.

Negative space is a resultant shape that appears when design is filled in around it. Due to the nature of formline, negative space often appears as trigons (three-pointed shapes that change shape depending on the positive space around it), crescents, U-shapes, and S-shapes and sometimes other less-related, abstract spaces. To see trigons and crescents, see page 13.

The primary space is often black:

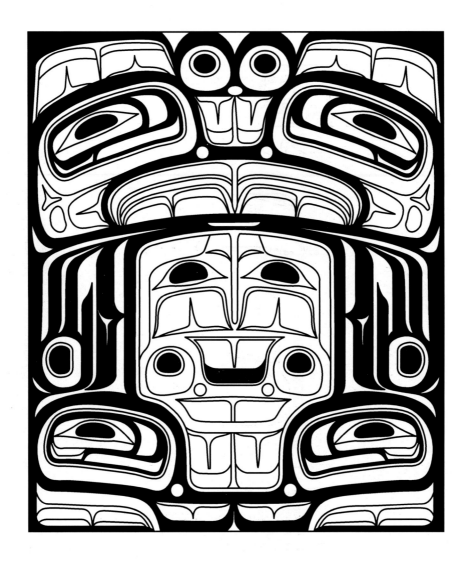

The secondary space is often red:

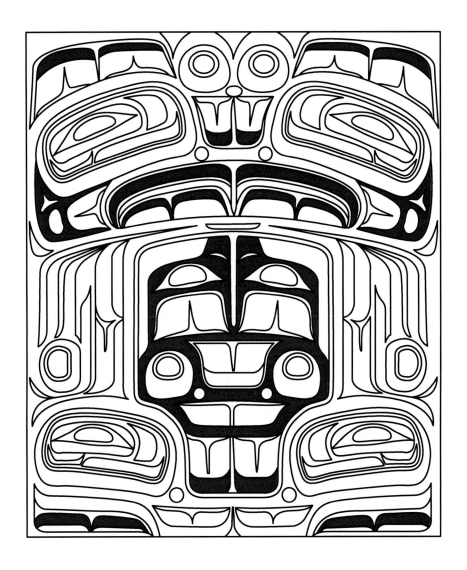

The tertiary space is often blue-green:

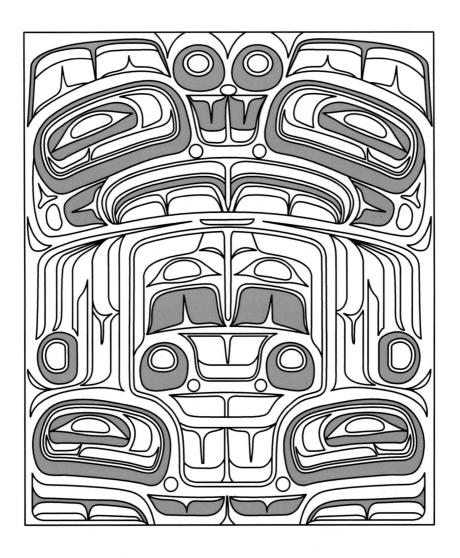

Primary (black or red), secondary (red), tertiary (blue-green), and negative (blank) spaces:

crescent

trigon

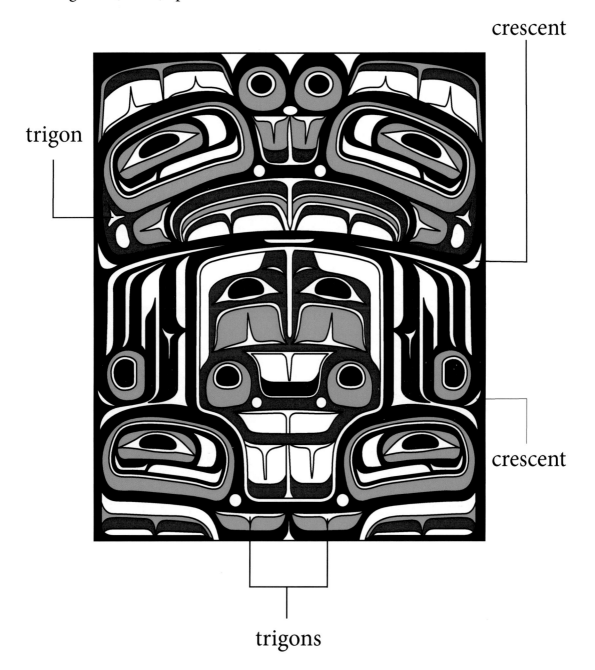

crescent

trigons

BASIC DESIGNS

HUMAN FIGURE

round
nose

ribs

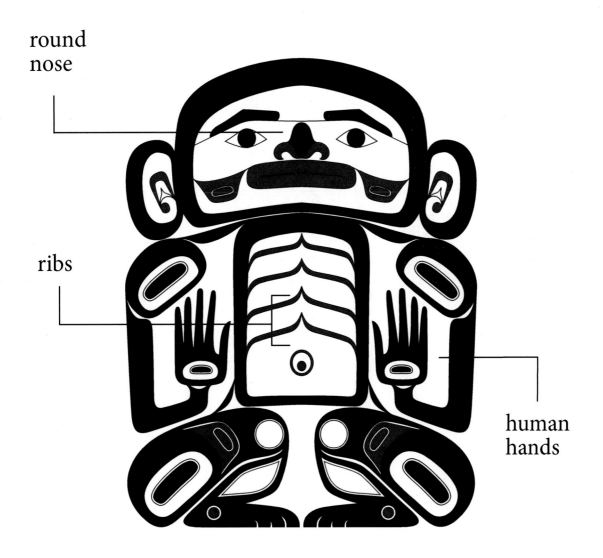

human
hands

EAGLE (PROFILE)

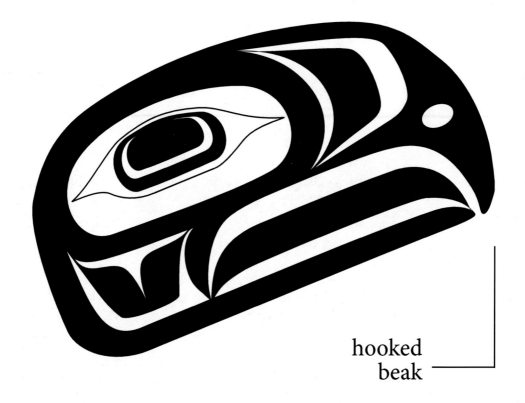

hooked
beak

EAGLE (FRONT)

Note where primary, secondary, and tertiary shapes exist in this Eagle design.

wing

hooked beak

claws

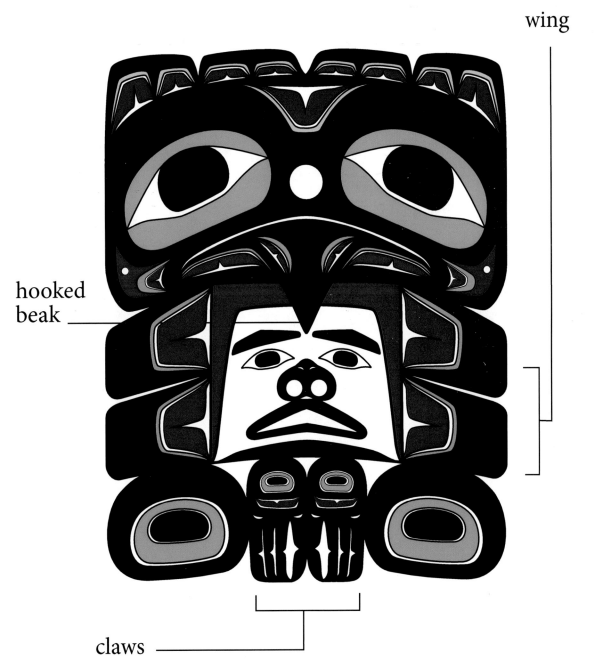

RAVEN (PROFILE)

ears

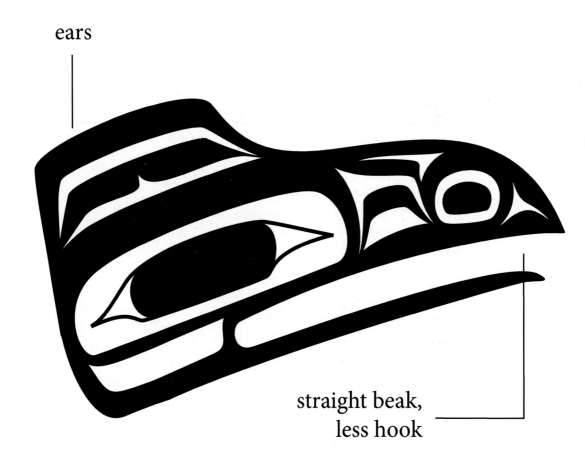

straight beak,
less hook

RAVEN (FRONT)

straight beak, less hook

ear

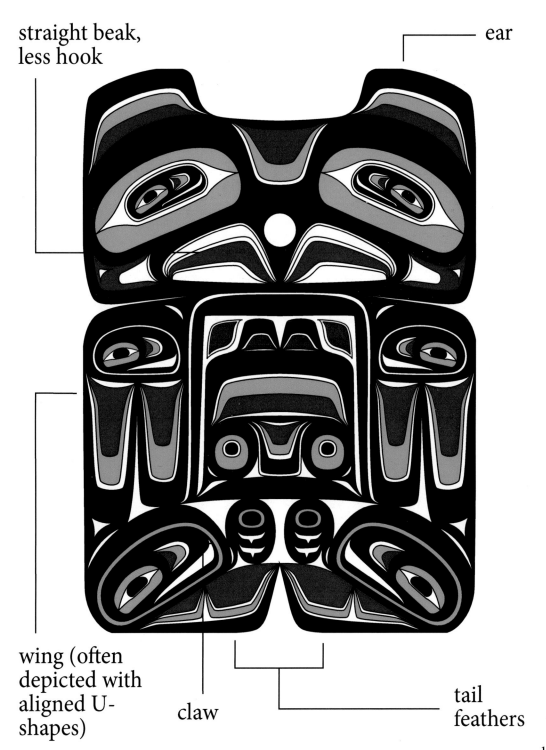

wing (often depicted with aligned U-shapes)

claw

tail feathers

19

CRESTS

A clan is the basic social unit in Tlingit society. It is the unit that owns property. This property is called *Haa At.óowu. At.óow* includes physical property, land, songs, names, stories, and crests. A crest is a design and a spirit with which a clan claims a significant relationship. This relationship often has to do with an important event in the clan's history. Crests usually depict certain animals or creatures that played a major role in that history. *At.óow* is fiercely protected in Tlingit property law and in modern Tlingit society.

SALMON

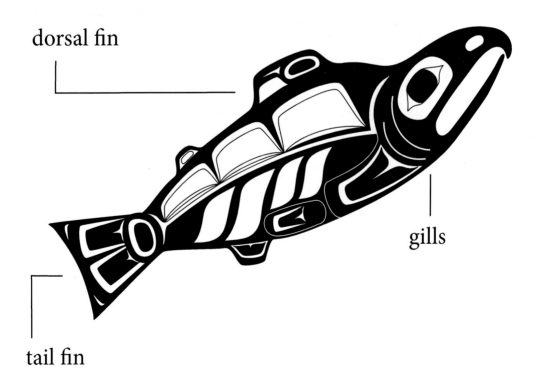

dorsal fin

gills

tail fin

KILLERWHALE

large dorsal fin

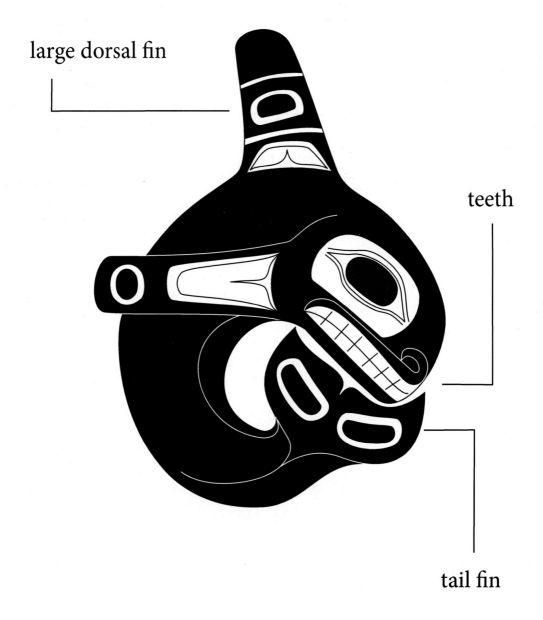

teeth

tail fin

BEAVER

large front teeth

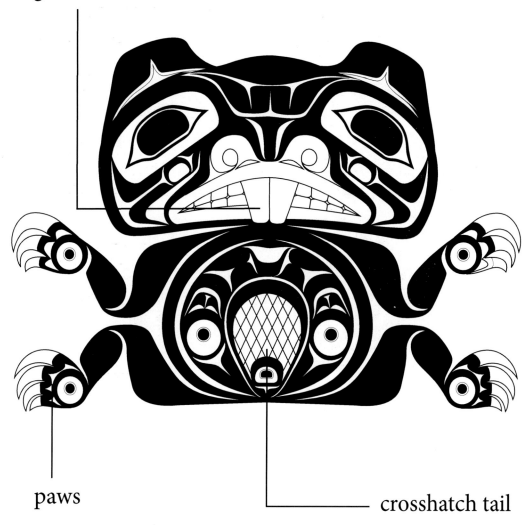

paws

crosshatch tail

FROG

hunched
back legs

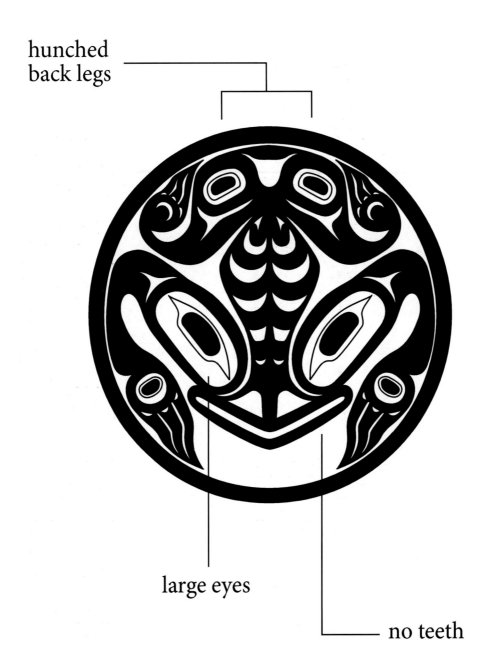

large eyes

no teeth

BEAR

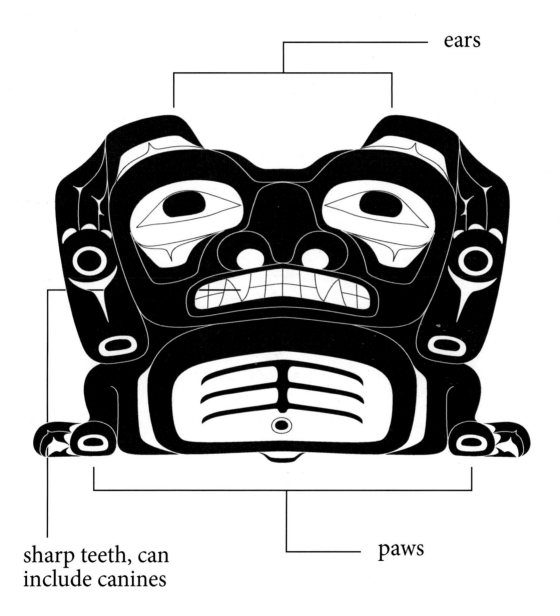

ears

sharp teeth, can
include canines

paws

WOLF

tall ears

puffy tail

teeth, can
include
canines

puffy paws

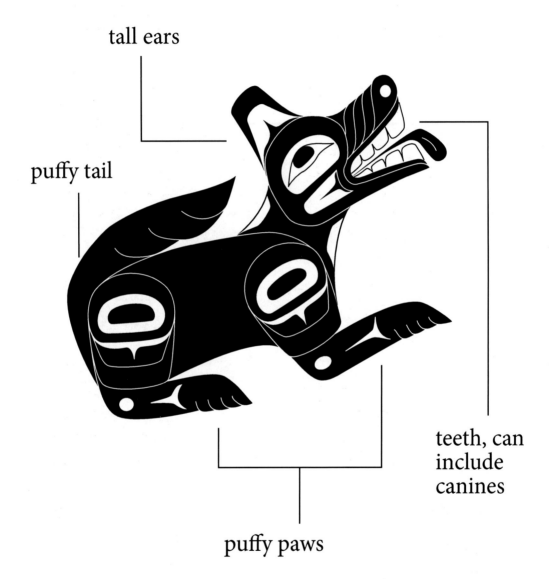

SHARK (FRONT)

round shark
nose-shaped
head

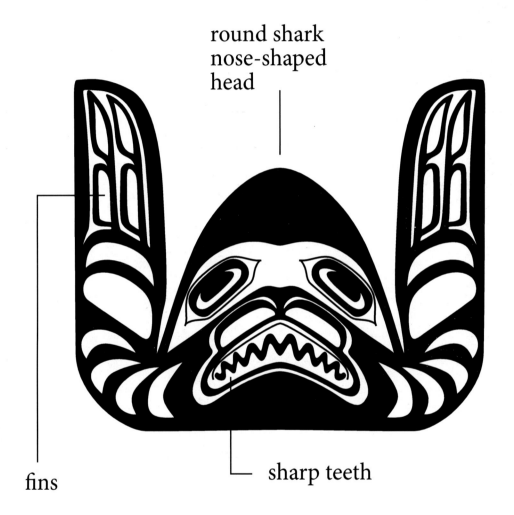

fins

sharp teeth

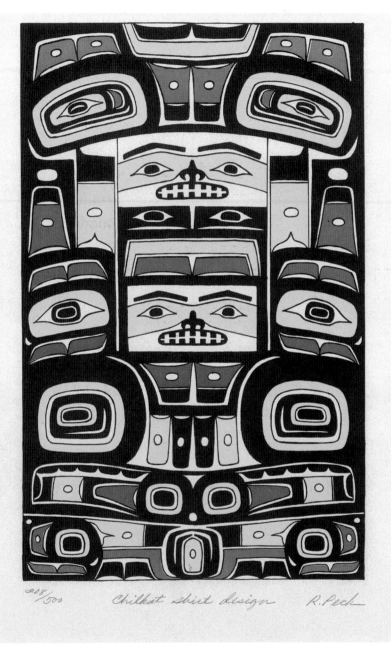

208/500 Chilkat shirt design R. Peck

"CHILKAT SHIRT DESIGN" BY RAY PECK.

CHILKAT DESIGN

FORMLINE IN CHILKAT WEAVING

Chilkat formline is an alternate style of formline design. The rules of design are essentially the same, but the technical process of both the weaving and the dye making have led to a very distinct style.

The design process is a collaboration between carvers and weavers. The carver paints the primary design on a pattern board. The pattern board then works as a form template for the weaver to follow. The designs must be created acknowledging the technical restraints of the warp and the weft. Warp is the line of material going up and down, weft is the material going from left to right.

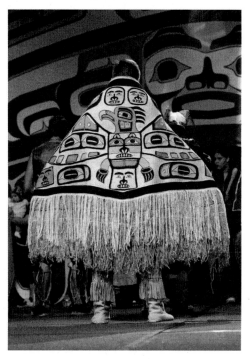

CHILKAT ROBE DEPICTING A XEITL (THUNDERBIRD). THIS CREST BELONGS TO THE SHANGUKWEIDÍ (THUNDERBIRD CLAN). PHOTO BY BILL HESS, SEALASKA HERITAGE INSTITUTE COLLECTION.

Because of the linear nature of the material, much Chilkat formline comes across as more angular than standard formline. As with standard formline, the design is broken into primary, secondary and tertiary spaces. Respectively, the colors used are usually black, yellow and blue-green.

ABSTRACTION

The characteristics in the designs you see will not always be easy to read. The designs we have shown you so far are "configurative" designs. There are three levels of abstraction in formline.

1) <u>Configurative</u>
Configurative designs clearly depict the creature being depicted. The features of that creature will be in anatomically correct places with very little to no distortion.

2) <u>Expansive</u>
Expansive designs will often depict an image with key features of the creature being displaced or distorted slightly. This often happens when an artist is trying to ensure all the features fit within a limited canvas.

3) <u>Distributive</u>
Distributive designs are entirely abstracted. The form of the creature is unrecognizable. Features may still be there, but the focus is purely on flow of the form rather than anatomy. (See Chilkat design on page 28)

Even experienced artists can have difficulty deciphering more expansive and distributive designs.

TEST YOUR SKILLS!

Test your formline interpretation skills! Look at the following designs, and see if you can determine what is being depicted.

Design 1: _____

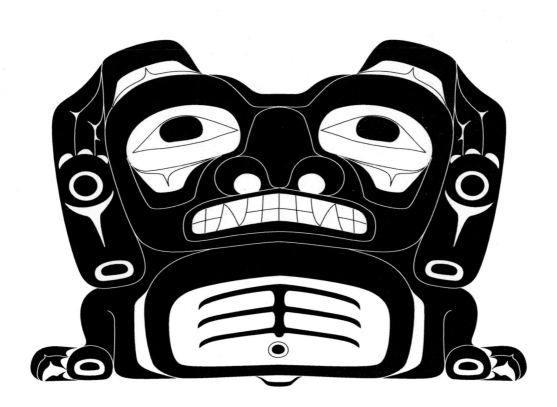

Design 2: _____

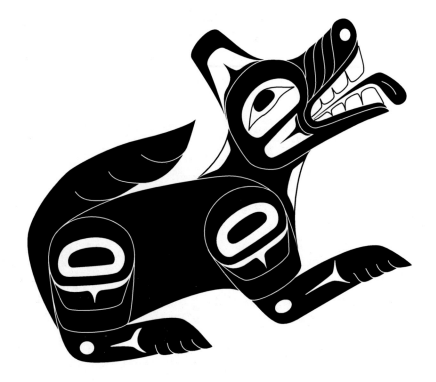

Design 3: _____

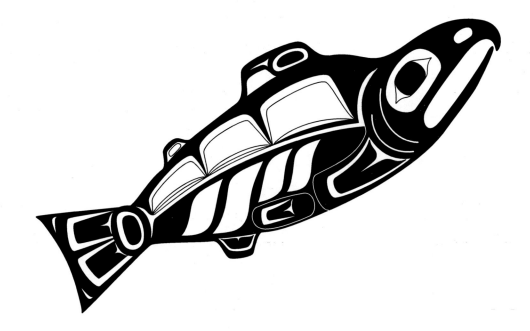

Design 4: _____

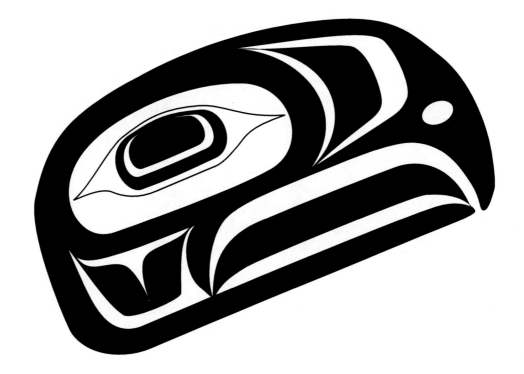

Design 5: _____

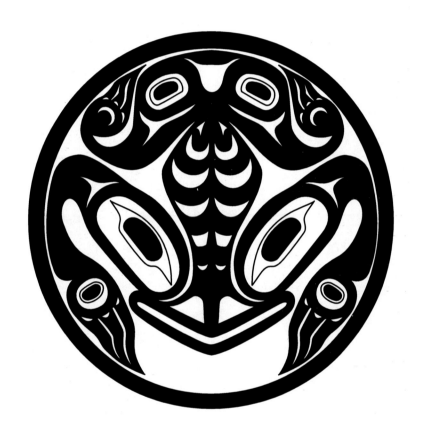

Design 6: _____

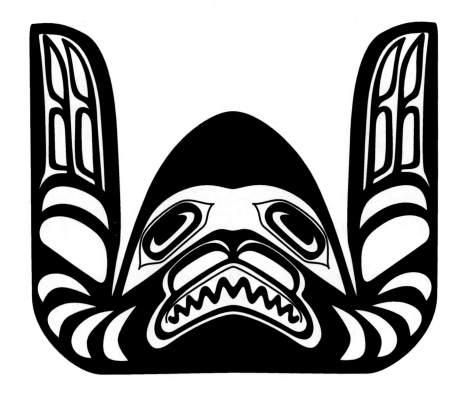

ANSWERS

Design 1: Bear
Design 2: Wolf
Design 3: Salmon
Design 4: Eagle
Design 5: Frog
Design 6: Shark

ACKNOWLEDGEMENTS

The illustrations in this book were made by a number of artists. The formline on the cover and most of the designs in the chapter on crests were made by the late Tlingit artist Amos Wallace and digitized by Rico *Lanáat'* Worl and Crystal *Kaakeeyáa* Worl. Amos was a master artist who traveled the nation educating people about Northwest Coast formline. We thank his son, Brian Wallace, and the rest of the Wallace family for donating Amos Wallace's illustrations to Sealaska Heritage Institute to teach future generations about formline.

Other illustrators include Donald *Héendeí* Gregory, Yukie Adams, Ray *Aaan eetí lootl* Peck, Nathan *Yéilyádi* Jackson, Rico *Lanáat'* Worl, and Crystal *Kaakeeyáa* Worl.

Special thanks to Sealaska Heritage Institute's Native Artist Committee members Nathan *Yéilyádi* Jackson, Delores *Ills'kyalliass* Churchill, Steve *Kajisdu.áxch* Brown, and Nicholas Galanin for reviewing this manuscript and giving guidance.

Special thanks also to the Alaska Humanities Forum and the National Endowment for the Humanities for funding this project and making production of this book possible.

REFERENCES

Brown, Steven C.
 1998. *Native Visions: Evolution in Northwest Coast Art from the 18th through the 20th century*. Seattle: University of Washington Press.

Holm, Bill
 1965. *Northwesat Coast Indian Art: An Analysis of Form*. Seattle: University of Washington Press.

Made in the USA
Las Vegas, NV
24 March 2021

20082239R00031